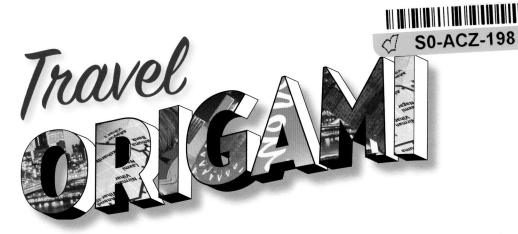

Travel ORIGAMI

24 FUN AND FUNCTIONAL TRAVEL KEEPSAKES

CINDY NG

TUTTLE Publishing

Tokyo | Rutland, Vermont | Singapore

Contents

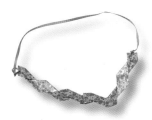

PART 3: *ORGANIZATIONAL HOLDERS* . 62

PART 4: *HOME DÉCOR ITEMS* 84

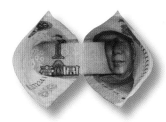

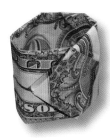

Introduction

Shortly after my book *Girligami* was published, I traveled to Istanbul hoping for a creative and restorative getaway. Luckily for me, I came back with beautiful patterns, currency notes, and the idea for *Travel Origami*. With the new book idea not quite fully formed, I gathered all my souvenirs and naturally started folding them into origami. Sometimes the final result of the folding sequence didn't have a name, but it was beautiful to look at. Some weren't quite as aesthetically pleasing, but they were really useful. After making a couple of rings and abstract models with printed patterns, currency and paper bags, I realized my affinity for objects with dual functionality. With that in mind, I went off the beaten path and started creating origami models for *Travel Origami.*

I hope that *Travel Origami* will act as a catalyst for exploration and introduce to you my cheery origami world. You'll discover maps that can be reworked into arrows and holders, currency that can be transformed to fun rings for your fingers, and bags that can magically morph into abstract infrastructures.

With just the right balance of patience and fun, Travelgami will give you something to really boast about when you have both a souvenir and a piece of beautiful origami art!

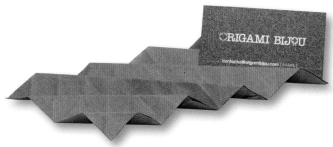

Essential Tips

Origami paper likes a flat, clean surface. Work on an oil-free table or countertop, or even a hardcover book.

Cut carefully! Since you're working with things like maps and brochures, you'll need to cut some of your sheets to the right size and shape Grab a ruler, a pencil and a pair of scissors (or, if you want to be super-precise, buy a craft knife from your local craft store, a cutting mat, and a metal ruler). Follow the "measure twice, cut once" rule when planning and drawing your square/rectangle. Take your time and cut carefully. Always use scissors and craft knives with caution. Children should be supervised or assisted by an adult.

Begin by orienting your paper exactly as shown in the first step.

Follow the markings. Dashed lines show where to fold, while arrows show in which direction to fold. When you see a circle with an arrow, the circle indicates where to pinch or hold the paper as you fold in the direction of the arrow.

First impressions are everything! For many types of paper the very first fold quickly commits to memory, so it helps to be precise and neat. Keep your origami in shape by running your thumbnail along each fold several times.

Some of the paper you use will come with its own creases and wrinkles. Shoot for paper that is as smooth as possible, but if you are stuck with premade creases, try to be mindful of them as you make your own creases and folds. Steer clear of mangled paper altogether.

 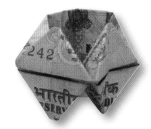

Review all the steps before you start folding a model. Then, as you're folding, it helps to keep looking ahead to the next illustration to see what will follow the step you are working on.

Don't take yourself too seriously!
If you do, origami is zero ounces of fun. if you're feeling frustrated, take a break and come back to it later.

Share your origami with traveling companion.

Why I love origami...
Origami is a vehicle of creativity and innovation for me. It creates beautiful and satisfying results in minutes, not to mention the fact that a piece of paper is quick and easy to find!

Here are some of the things origami can do for you, too:

Origami ...
- *fosters your visualization skills*
- *calms your nerves as you focus on folding (and not on whatever is stressing you out)*
- *tricks you into learning geometry*
- *increases your self-confidence as you master increasingly difficult models*
- *entertains you when you are procrastinating*
- *gives you thoughtful, pretty, economical gifts for family and friends*

I hope you find origami as fun and engaging as I do. Happy folding!

Some of the paper you use will come with its own creases and wrinkles. Shoot for paper that is as smooth as possible, but if you are stuck with premade creases, try to be mindful of them as you make your own creases and folds. Steer clear of mangled paper altogether.

A Guide to Origami Folding Symbols and Terms

ACTION SYMBOLS

------ **dashed line**

A dashed line indicates where you need to fold or crease.

_____ **solid line**

A solid line shows where a crease has been made that now serves as the guide to where the edge of your origami paper should align.

TERMS

crease

To fold and unfold the paper, leave a line or ridge to serve as a guide for a future fold.

fold

To bend your sheet of paper over, under, behind, or on top of itself so that one part covers another. This creates the framework for the origami model.

Flip over from side to side

COMMON FOLDS:

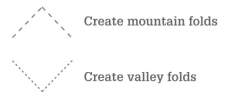 Create mountain folds

Create valley folds

A mountain fold is created when the folded edge is along the top.

A valley fold is created when the folded edge is along the bottom

Fold in

Result

Fold up

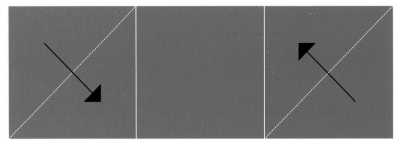

Fold down

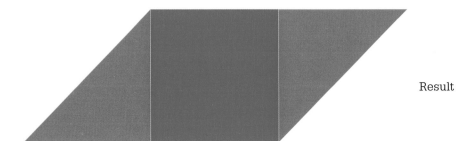

Result

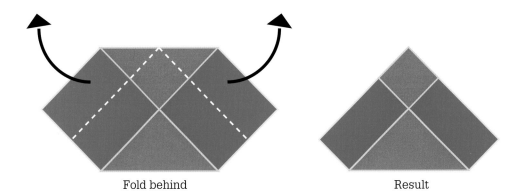

Fold behind

Result

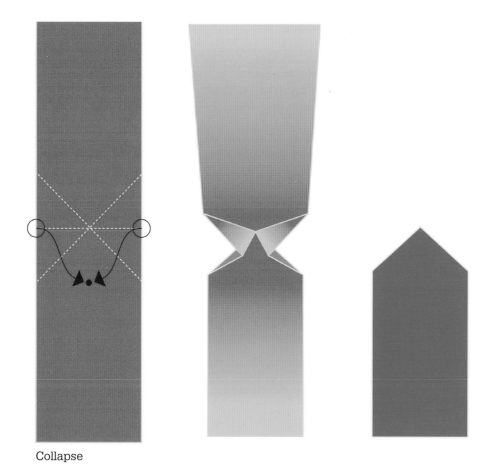

Collapse

For this fold, pinch sides of paper where indicated with circles and carefully bring them in and down to meet the bottom edges, as shown by the arrows. Look at the illustrations to see the collapse in progress.

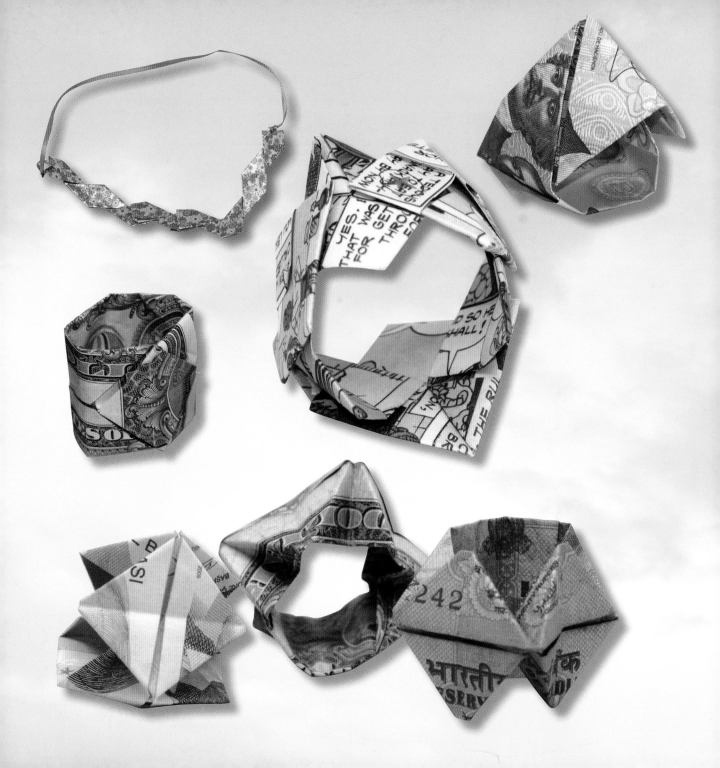

Jewelry

Candy Wrapper Necklace

Why candy wrappers? When I'm lucky, I stumble upon a sweet that gives me two for one—a party in my mouth and the joy of having a great candy wrapper as a memento. And it's fun to see how other countries like to wrap their candy (it's fun to eat their candy, too). Lots of imported treats are available on online, and most major cities have foreign delis where you can find all kids of great stuff, from candy in packets to unusual, tasty food that's good for you.

Here's a way to turn your candy wraps into something more. If you like, coating the finished necklace with a sealant like Mod Podge® or other brush-on (or spray-on) sealant/ glaze will help the necklace—or any paper jewelry—stand up to handling and wear. Just be sure the sealant is completely dry before slipping on your chic new trinket. You'll need a minimum of five candy or gum wrappers, trimmed to a rectangular shape. The diagrams are based on a 1.75" x 2.25" rectangle.

2 Rotate 90 degrees.

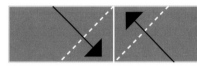

3 Fold left side down and right side up, as shown.

1 Fold in on both sides.

4 Make 4 more.

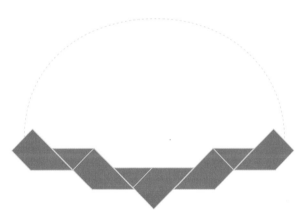

5 Align the ends together as shown and adhere them with double-sided tape.

Find a fun ribbon and loop onto the ends. Adhere with safety pins or double sided tape. You can do this any way you like. If you'f like to use more wrappers and less ribbon, do it! Just be sure to use an odd number of wrappers so you'll have a nice point in the middle. You can make this large enough to slip over your head, or you can snip the ribbon loop in half and tie it around your neck.

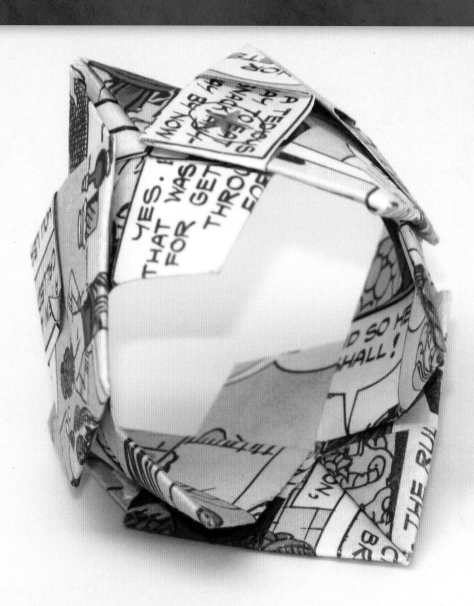

Why comic strips: Comics are fun to read as kids and kidults (adults who are really a kid-at-heart). Comic book jewelry looks great in black & white as well as color. There's no shortage of drawing styles to choose from, and folding comics is a great way to play with different textures and thicknesses of paper (some are as thin as newspaper while others are of a much thicker stock. Beat-up comic books, manga books, and graphic novels are all great sources of paper

All cultures have their own comic books –(a good place to start exploring the different comics that are out there is http://en.wikipedia.org/wiki/Category:Comics_by_country)

Here's a way turn your favorite comic books into wearable art. As with the candy wrap necklace, you might want to give it a coat of sealant before wearing it. If you want to preserve the comic book texture, go for a sealant that has a matte finish.

Start by cutting a bunch of 2" x 2" sheets.

1 Fold and unfold along both diagonals.

2 Fold in as shown.

3 Fold behind.

4 Flip over from side to side.

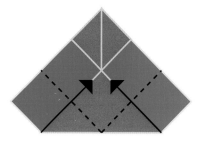

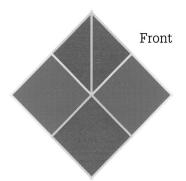 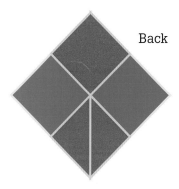

Front Back

5 Fold up.

6 Front and back views. Fold as many as needed to wrap around your wrist (make the bracelet big enough to slip your hand through).

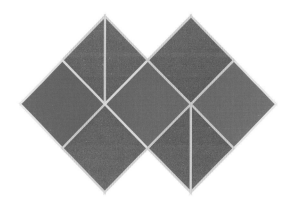

7 Connect the pieces by interlocking the "open" diamonds.

Money Diamond Ring

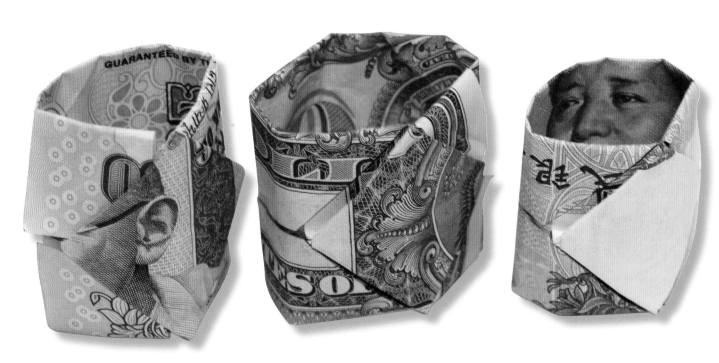

Paper money is one of the most popular things to fold. For one thing, it's fun to work with the shape and texture of a dollar, whether it's a US dollar, a Canadian dollar, an Australian dollar…. (Lots of countries refer to their currency as the Dollar, though the sizes and colors can be different from what you're used to. That's part of the fun.) The currency of different countries is a fun way to explore origami and get a little lesson in culture and economics on the side.

Why a diamond ring: In movie scenes, the proposal and the diamond ring feel like the most romantic thing ever. If you're a fan of origami, transforming currency into your own movie moment might not be such a bad idea. It would make one great romantic temporary engagement ring, friendship ring or "going together" ring.

Here's a way to transform currency into your own happily-ever-after.

1 Fold top corner down as shown. Unfold.

2 Fold bottom corner up as shown. Unfold.

3 Make a fold down the center of the X shape made in steps 1 and 2. Unfold.

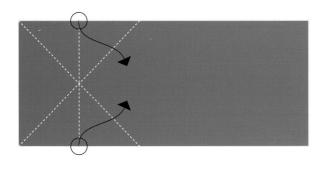

4 Take the edges at the circles and collapse inward.

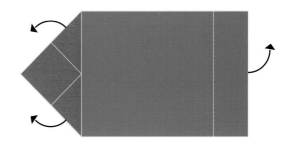

5 Tuck the arrow flaps under and fold the bottom edge behind.

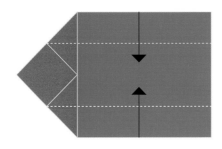

6 Fold the sides in.

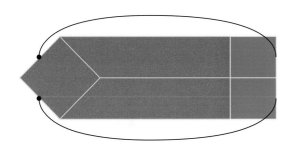

7 Loop behind and insert the tips of the bottom into the sides of the diamond.

Punk Rocker Ring

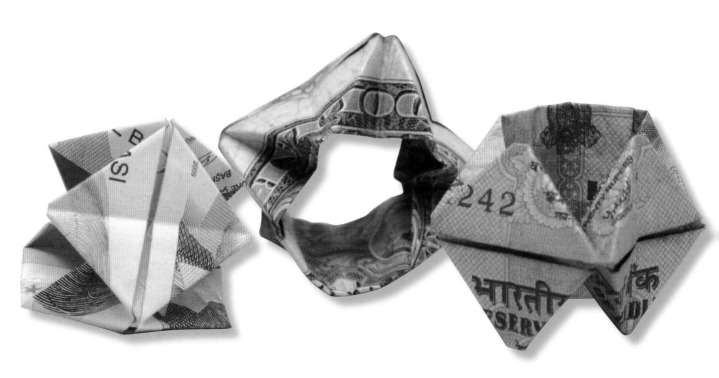

Why punk rocker? On a recent trip to New York's Metropolitan Art Museum I visited a beautiful exhibition on Punk. I hadn't realized before that punk's concept of "DIY" had had such influence on fashion. The exhibit was pretty spectacular, and it made me realize that we have Punk to thank for a good chunk of the freedom and creativity we see in today's design.

Especially when it comes to fashion, nothing embraces the beauty of found objects—even some pretty grim-looking stuff—the way punk does. Any fashion accessory you invent with paper fits perfectly with that make-it-yourself, make-it-your-own approach, but I especially like this ring for its bold, spiky sort of look. And, in keeping with the philosophy that you don't need much money as long as you have imagination, it's a way to revel in punk for as little as a dollar—literally!

1 Fold sides in center lengthwise.

2 Flip over side to side.

3 Fold in half left to right.

4 Fold in half left to right again.

5 Fold left side corners in through all thicknesses. Fold just the top (folded) potion of the right corners in. Your model will look like this

a Create mountain creases

b Create valley creases

c Fold in

d loop and insert

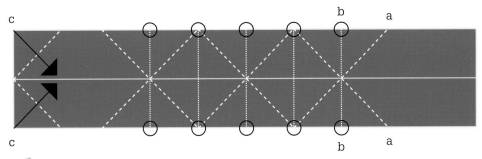

6 Unfold back to step 2. Fold in the left corners. At the collapse at the circles.

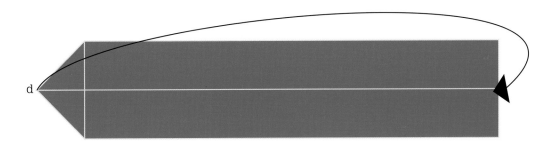

7 Loop the around and insert pointed end in to close.

Modern Money Ring

Why modern? When I'm in a new city and observing its architecture, I find that simple curves and lines of a modern building can be just as beautiful as the intricate details on a Victorian house. I feel the same way about jewelry. This modern ring looks sleek in almost any currency and takes just a couple of minutes to make.

Here's a fun way to ring in modern times.

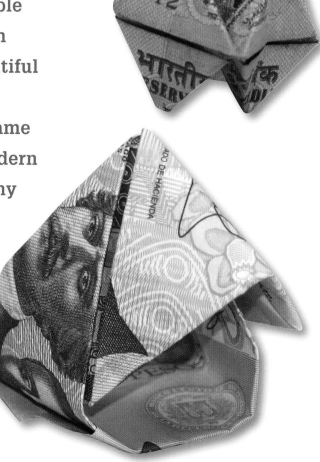

1 Fold in.

2 Fold in half vertically and unfold.

3 Crate three horizontal folds as shown.

4 Fold up.

HINT: There are a lot of interesting faces on the world's different currencies. They give us a little lesson in world history. Unlike US dollars, which place the portraits in the center, many foreign currencies place their portraits off to the side. For a fun challenge, try folding your currency so that the face is exposed in an interesting way.

5 Fold behind and over.

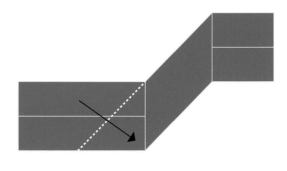

6 Fold Down.

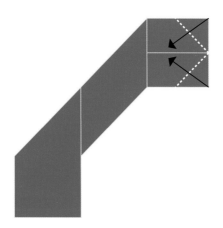

7 Fold in.

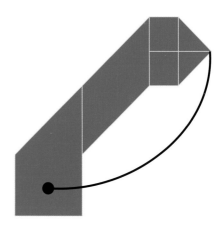

8 Loop over and insert.

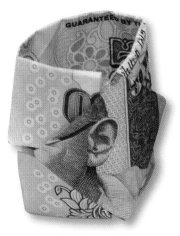

This ring was made using a 50-rupee note. That's Gandhi's ear you're seeing. His face appears on all denominations.

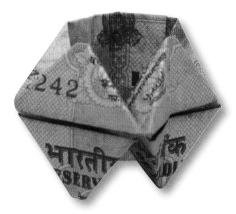

Most countries use different colors for different denominations. This ring was made with a 20-rupee note (Gandhi is folded up somewhere inside).

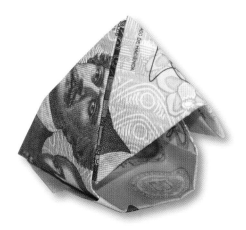

This Dominican Republic 100-peso note actually has three portraits on its front (though only about one and a third faces can be seen here).

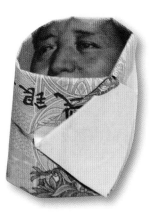

Chairman Mao's face looks out from the inside of this ring. His face is on most (though not all) denominations of the Yuan.

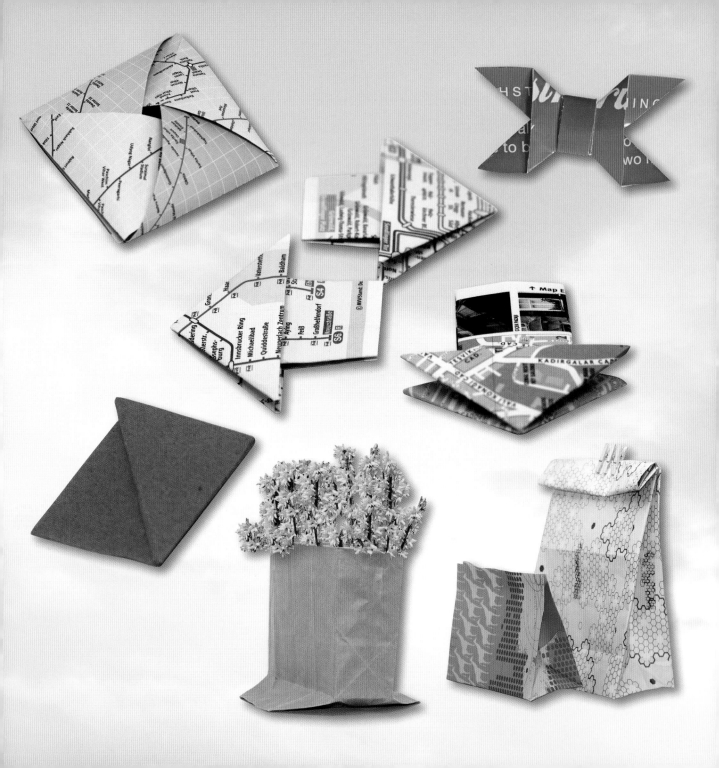

Odds n'
Ends

New Kind of Envelope

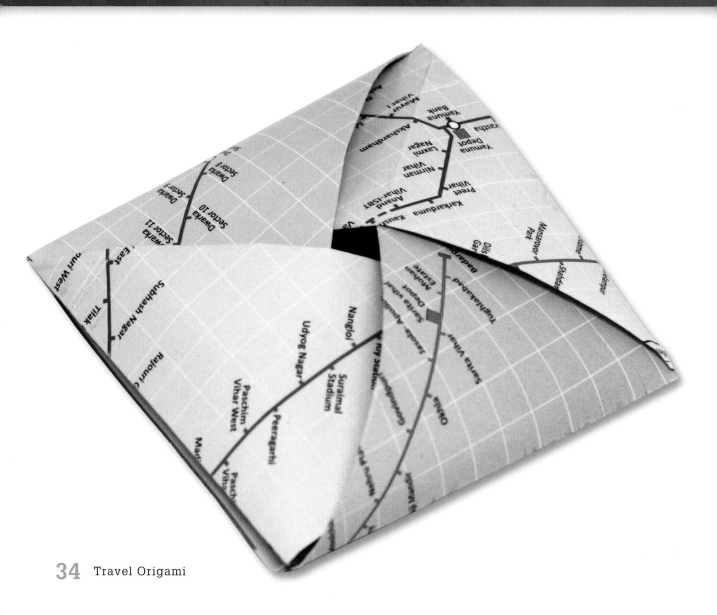

Why a "new kind" of envelope?

Letters enclosed in a different wrapping makes the thought of opening a letter more exciting, don't cha think? When you share an epic trip (or a meal or a special event) with a friend, it's fun to get a letter tucked in an envelope that brings back memories—as much of a keepsake as the letter itself!

Here's how to create an exciting experience for someone you love. It all starts with two 3" x 9" sheets (or 5" x 15" for a longer envelope).

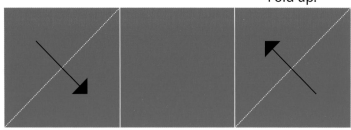

Fold up.

1 Fold top corner down and bottom corner up, as shown.

Fold down.

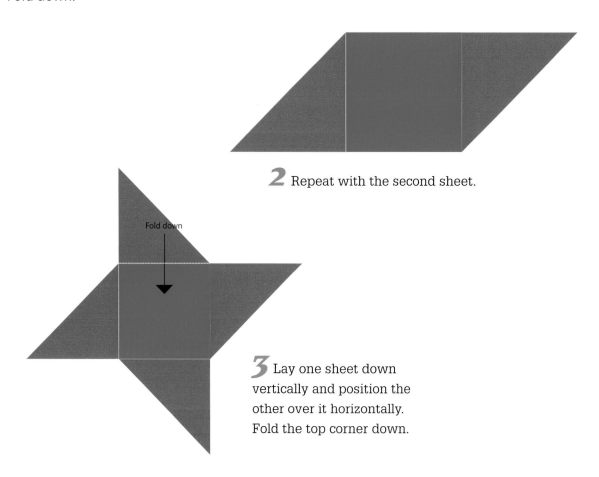

2 Repeat with the second sheet.

Fold down

3 Lay one sheet down vertically and position the other over it horizontally. Fold the top corner down.

4 Fold the bottom corner up.

Fold up

5 Fold the bottom corner up.

6 Tuck the sides in to close your envelope

Gift Wrap Paper Bags

I love buying pretty gift wrap paper when I'm in a new country because it's an easy and affordable way to collect art and bring home a souvenir. My new "art" piece hangs on my studio wall for about a year, but as time goes on I get a hankering to breathe new life into it. So what do I do?—I transform it into a paper bag!

You can do this with anything of a workable size and shape—an interesting map, or an old poster can do the job just as well. Or make smaller bags from smaller paper sources. Anything will work as long as the shape is right and the measurements are proportionate.

Here's how to breathe new life into any pretty paper.

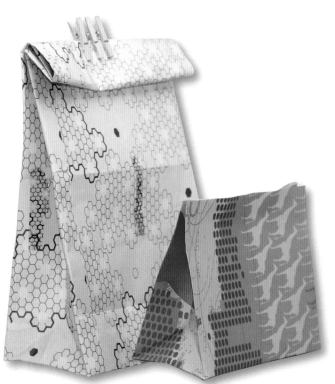

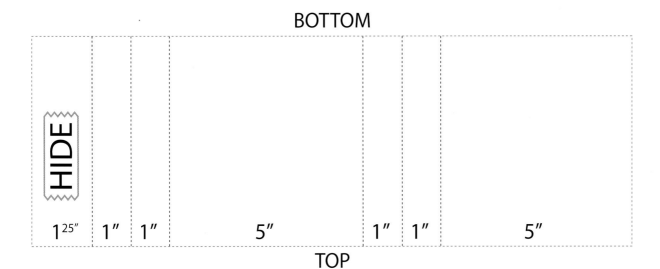

BOTTOM

HIDE						
1$^{25''}$	1″	1″	5″	1″	1″	5″

TOP

BOTTOM

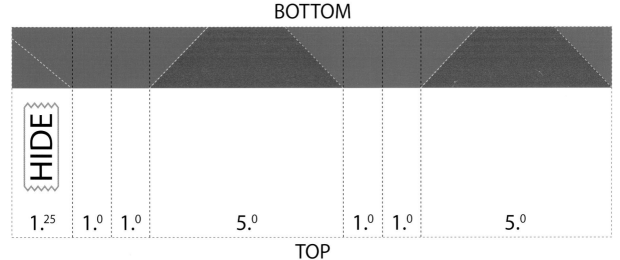

HIDE						
1.25	1.0	1.0	5.0	1.0	1.0	5.0

TOP

Find a sheet of paper you'd like to turn into a bag. You'll need something at least 6-8 inches high and 15.25 inches wide. Grab a pencil, ruler and scissors to mark and cut out your rectangular sheet.

 That's where you'll adhere the height of the paper bag. Double sided tape works best.

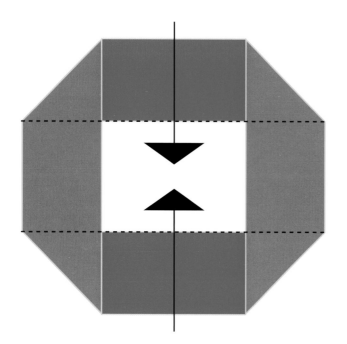

1 Lay the pretty side down. Mark off the measurements shown (mark the top of the page, the bottom of the page or both, or draw a fold line all the way down—as long as you mark the invisible side). Make valley folds along your lines.

2 Turn the top down about 1.25 inches. This will become the bottom of the bag. Make diagonal folds, using the straight folds you made in step 1 as a guide. Unfold back to step 1. Tape your bag at the side. Double-sided tape works best.

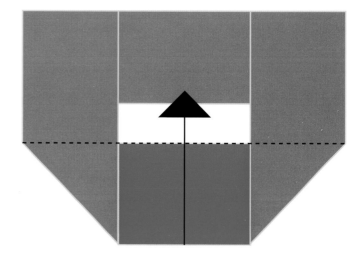

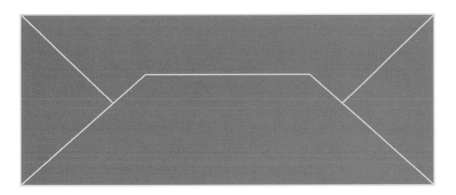

3 Turn your bag up. To form the bottom, fold down the short sides, then the long sides and adhere with double-faced tape.

> ***HINT:*** if you're making markings on dark paper, a dressmaker's chalk pencil (white) will allow you to draw sharp visible lines.

Corner Book Mark

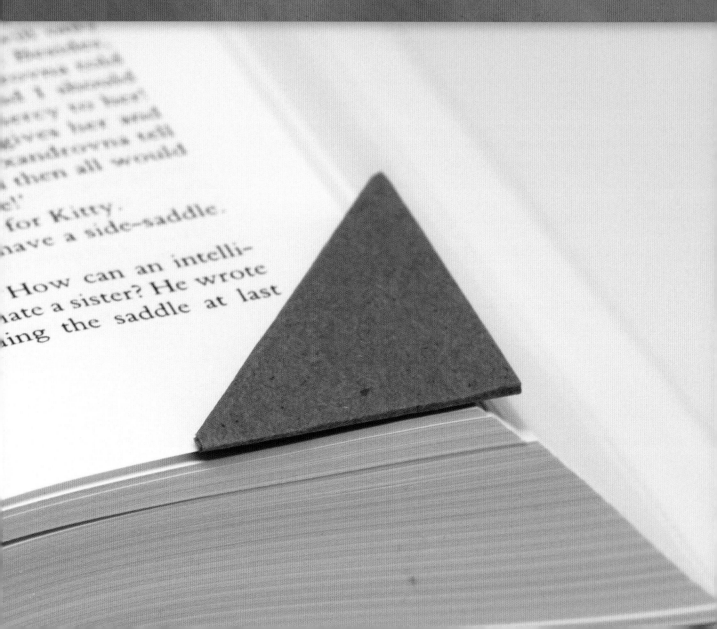

My rule of thumb is: whenever I can make something myself using a process I enjoy, I should always DIY. That's how I feel about bookmarks. I can always make a new bookmark with scrap materials from a recent trip or just about anything lying around—a magazine, paper bag, pretty patterned paper, a piece of card stock. Sure, you can stick just about any bit of paper between the pages to mark your place, but actually making a bookmark is a kind of personal investment in your reading pleasure, and is a thoughtful addition to any book you give as a gift. And just as books take you to faraway places, there's always something special about marking your pages with something that reminds you of somewhere you've been.

Here's how to make your own super fun DIY experience. Start with a square that's 2" x 2" (or larger, if you like).

1 Fold the square lengthwise.

2 Fold top to bottom

3 Rotate clockwise 135 degrees. The folded point should be on the bottom. You'll have four open points on the top.

4 Fold three of the points down and inward to form a pocket. Crease neatly.

Final result.

That's all there is to it. Now just slide your bookmark over the corner of your page.

Paper Arrow

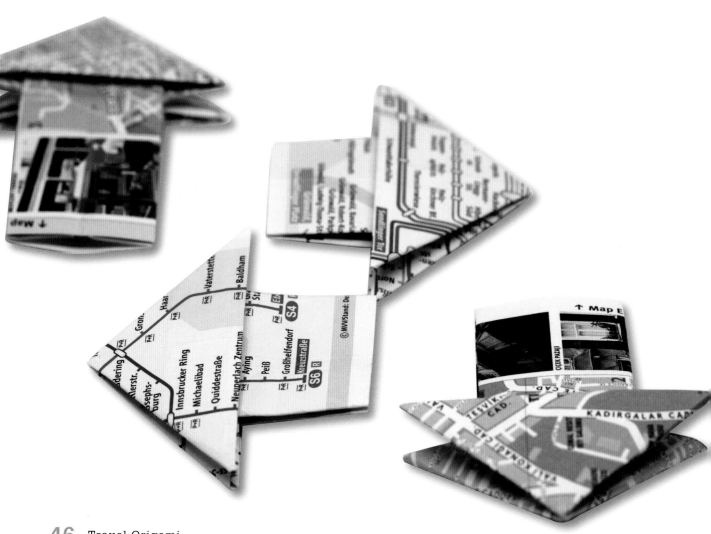

Directions for life: An uncle of mine told me that there are many different ways to succeed in life. It doesn't matter where you go as long as you find you own joy.

Here's a way to find your own direction.

You're sure to find lots of creative ways to use these. Make a bunch and stick them up to point someone to a place where a nice surprise awaits. Add a strip of magnet to the back and stick it on your fridge. Or, just use it to mark your place in your current read.

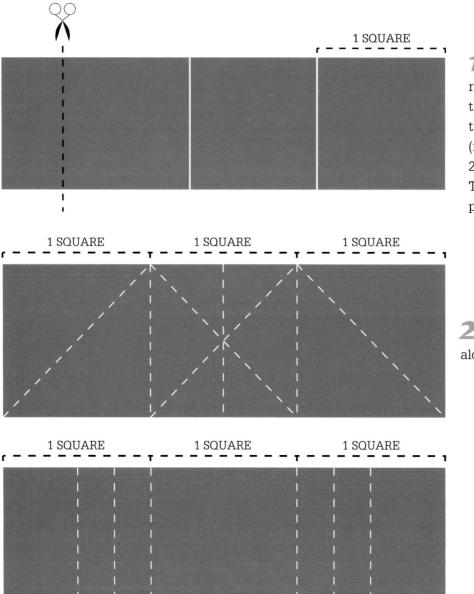

1 SQUARE

1 SQUARE **1 SQUARE** **1 SQUARE**

1 SQUARE **1 SQUARE** **1 SQUARE**

1 Start with a rectangular sheet that contains a row of three perfect squares (for example 2"x6", 2.5"x7.5" or 3"x9") Trim off any excess paper.

2a-b Make creases along dashed lines.

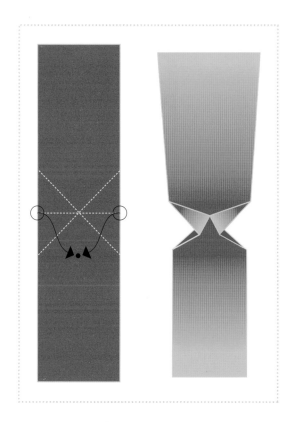

3 Collapse points inward as shown. Then unfold completely.

4 Fold in.

5 Fold corners up, and unfold.

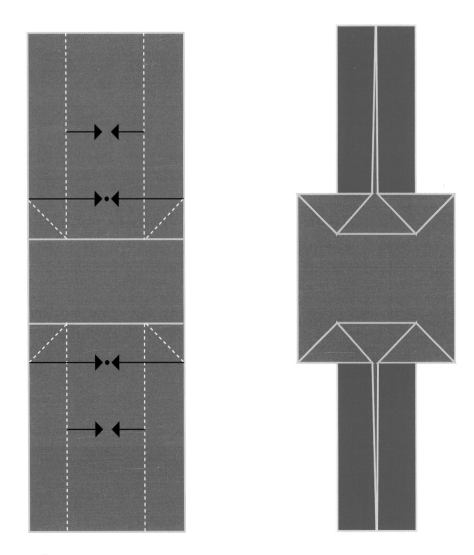

6 Fold long edges to the middle. Open out the middle section

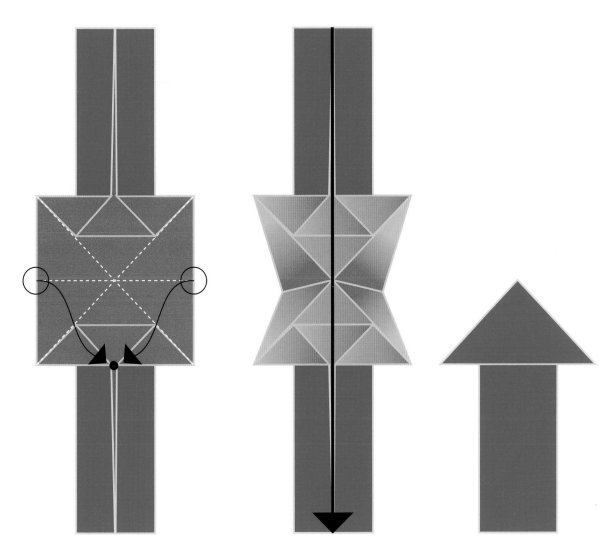

7 Collapse and fold in half.

Final result

The Octo Bag

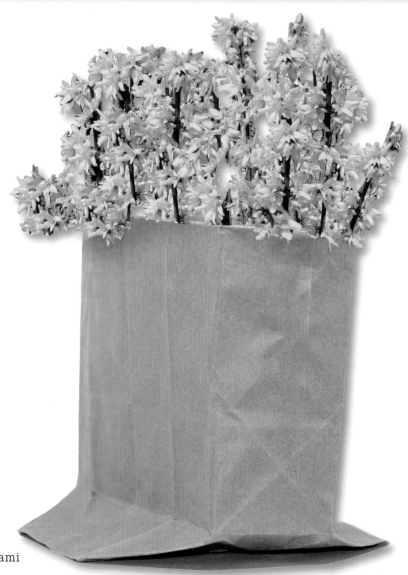

They might not seem like travel memorabilia, but think about it—we wouldn't need bags if we weren't going somewhere. And if we didn't enjoy them, we wouldn't save so many of the bags our travel souvenirs and treasures come in. Even the things we buy in our own home towns are often packed for us in bags we love to keep. And even with all the environment-friendly reusable bags we're using today (and that's a good thing!) you still see the old-fashioned paper bag everywhere—brightly colored and with a pair of handles from a chic shop, in classic brown and tough enough to get your groceries across town and cover textbooks for months, and a smaller version holding someone's lunch on a bench in Central Park. They remind me that even that lunch in the park or a trip to the grocery store can be a great adventure.

I love observing architecture in new cities

and countries, and one of my favorite styles is the octagon-shaped building. Octagonal or eight-sided structures have been built for centuries. The oldest known octagon is the Tower of the Winds built by the Greeks about 300 BC. Centuries ago, octagon-shaped buildings were very popular in Italy. If you can't go abroad, New York has a nice example on Roosevelt Island (http://www.octagonnyc.com). For this model, the base of a bag is folded into an octagon. The broad base makes this a stable container for all kinds of things like dried grasses and wildflowers.

HINT: You can do this with anything from a large grocery bag to a little lunch bag. The folds in the base make it stand up more steadily and the folds in the body give it an interesting look. The top fold gives it a neat finish. Try using a small one as a serving dish for pretzels or other dry, non-oily treats, or use a large one as a vase for dried grasses or cut corn stalks.

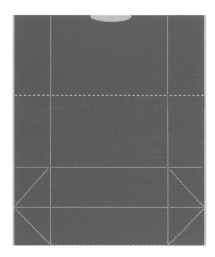

1 Lay the bag flat, bottom toward you, and make mountain and valley folds as indicated.

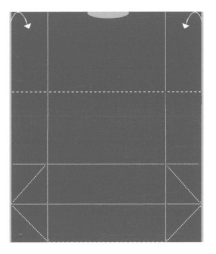

2 Fold inward from the top fold, making a finished top line.

3 Fold the corners of the bag bottom in, as shown.

These views will help you see where your folds should be.

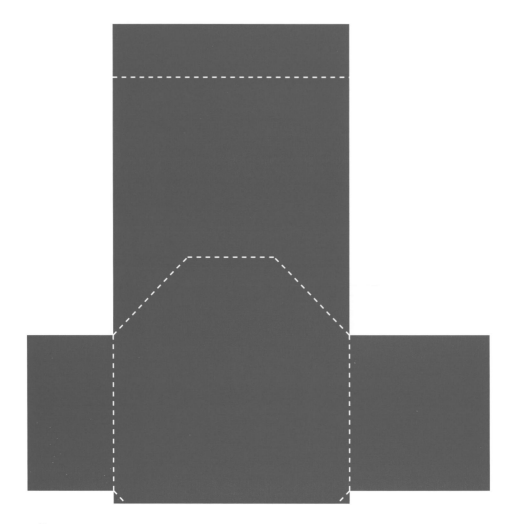

4 Stand your bag up and reach in, down to the bottom. Using your folds as a guide, push out the sides to form the flat base. When you're done, the base will form an octagon (hence the name!).

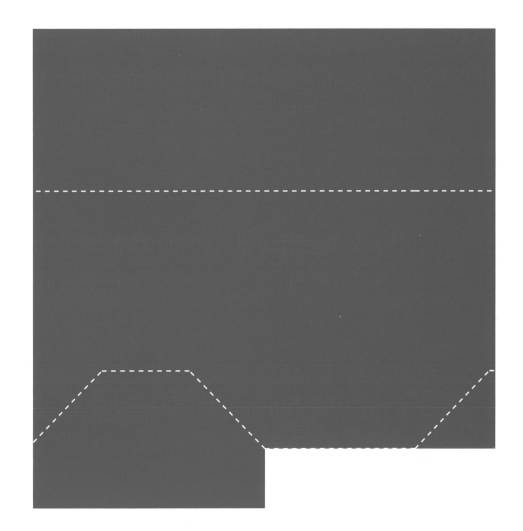

A Cute Paper Bow

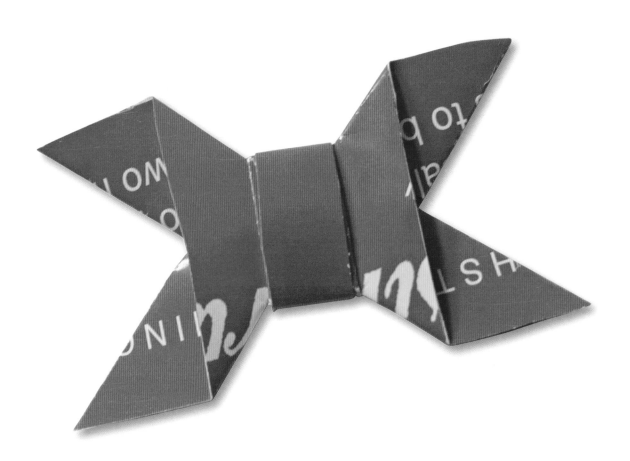

Some paper, like the wrapper for stick gum, comes ready-sized for this model, but it's easy to cut two pieces of a map, floor plan or pretty patterned paper to make this little what-not of a bow. Use it to decorate that gift brought back from somewhere special. Decorate a journal. Use it as a bookmark. Or wear it!

To make the snappy bow stylish travelers are wearing this season start with two stick gum wrappers or two 1.75" x 3.5" sheets.

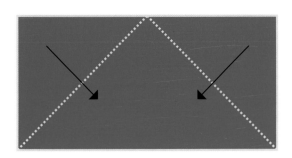

1 Fold corners in to bottom edge.

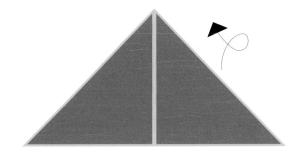

2 Flip over from side to side.

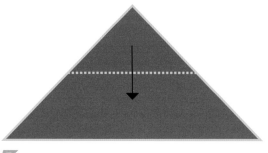

3 Fold corner down.

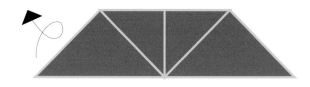

4 Flip over from side to side.

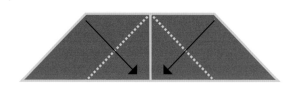

5 Fold Down.

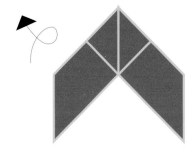

6 Flip over from side to side.

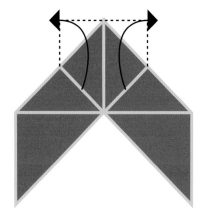

7 Insert your fingertips and gently pull sides out to form a rectangle.

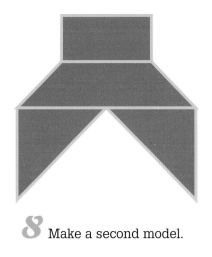

8 Make a second model.

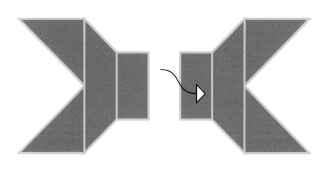

9 Insert one center into the other.

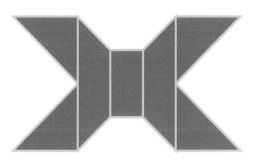

This is your finished bow. Tape it to a package, a drawing, or yourself! Add a ribbon and tie it around your head or your neck. Just like any other bow, there are lots of things you can do with it!

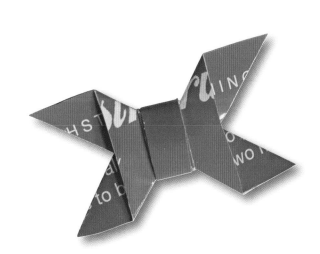

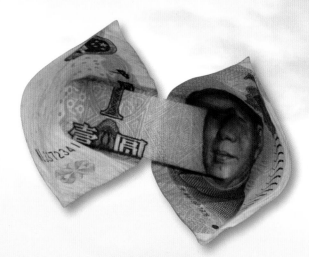

Organizational Holders

Photo Frame

Most tourist destinations have brochures about the place's history. I've found that they're usually the perfect size for making my photo stand up so can I look at my favorite photo from my trip. And the beauty of it is that you can customize the size to fit most photos.

Here's how to show off all the wonderful places you've been.

1 Working from an 8.5 x 11 inch sheet, measure the height of your photo (the one we're using here is 5"x 7"). Fold corners inward.

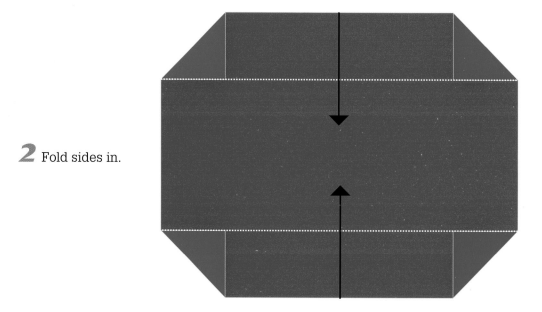

2 Fold sides in.

3 Flip over from side to side..

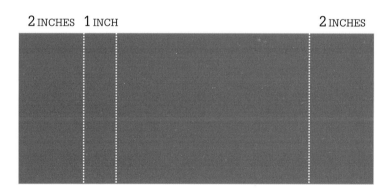

2 If you're using an 8.5"x 11" sheet, fold behind according to the measurements shown. Turn over side to side.

Slip your photos into the corners.

Metro Card Holder

Subway passes: I like to keep mine easily accessible but properly stowed. Little wallets like this one can also protect the magnetic stripe on your card.

Here's how to keep your transportation card neatly tucked.

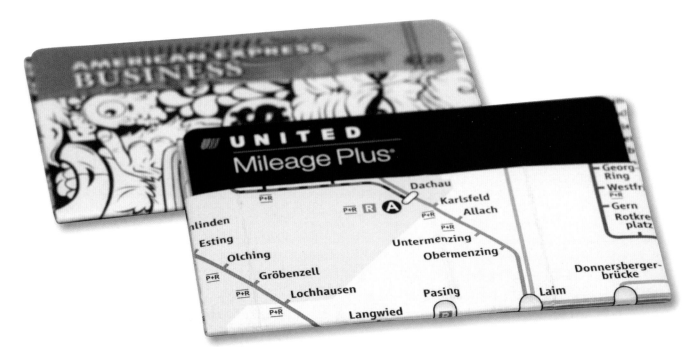

1 Use a square sheet big about 6" x 6". Place a metro card (or credit card or library card) in the center. Fold the sides over to fit.

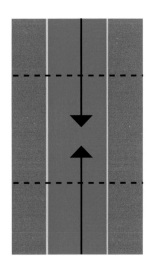

2 Fold in the top and bottom ends. Remove your card and refold your sheet if necessary.

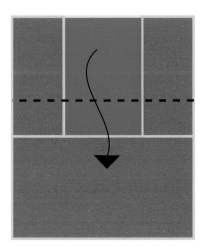

3 Tuck the top into the bottom

4 Final result. Slip a card or two into the pocket.

Business Card Holder

I like collecting different business cards

from restaurants when I travel because the cards are pretty and I get to remember all the different places I've been. When I have a pretty card, I like to stand it up where I can see it. This holder is like a frame, providing enough space to display it like a work of art.

Here's an easy way to display your business card like artwork.

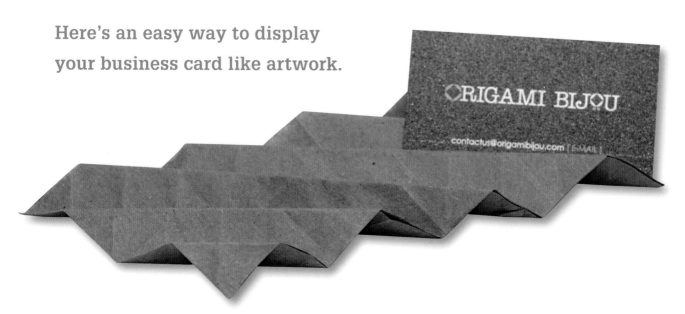

1 Take an 8.5" x 4.25" in sheet and fold in from top right

2 Fold point up to edge.

3 Fold point down to lower folded edge.

4 Unfold back to Step 1.

5 You now have a guide for making even pleats. Alternate mountain and valley folds until you get to the opposite corner. Be sure to fold carefully and make tight creases.

HINT: You can make these in all sizes and thicknesses. For holding bigger stuff, make a larger model and be sure your paper is pretty strong and your folds are pretty large.

Fortune Bowl

I often use bowls to hold coins and dollars, so it's fun it is to see dollars (foreign or domestic) transformed into bowls. These mini double-bowls can hold coins, rings and all kinds of little trinkets, especially items that have special meaning to you. Place the fortune bowl on your desk so you can glance at the items and smile.

This is how to make your own fortune bowl.

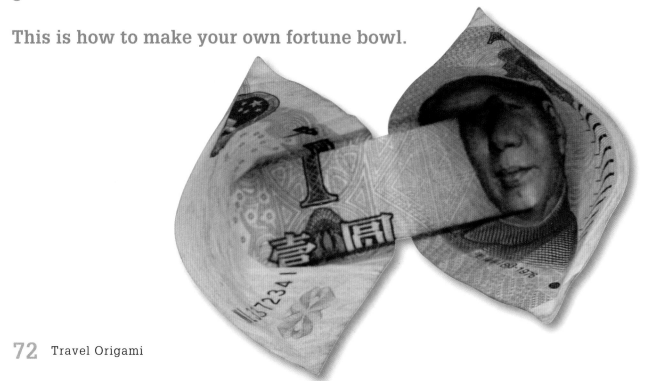

1 Fold top corner down as shown. Unfold.

2 Fold bottom corner up as shown. Unfold.

3 Make a mountain fold at the center of the X shape made in steps 1 and 2. Unfold.

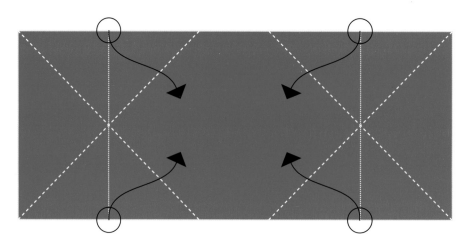

4 Take the edges at the circles and collapse inward.

5 Flip over from side to side.

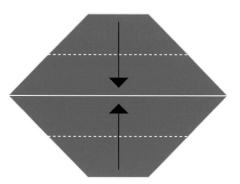

6 Fold top layer in to center (keeping the arrow points free).

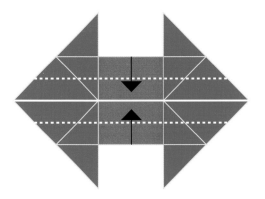

7 Fold in to center.

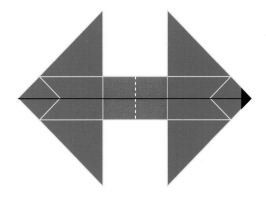

8 Fold left to right.

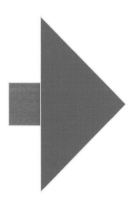

9 Use your finger to open up the bowls.

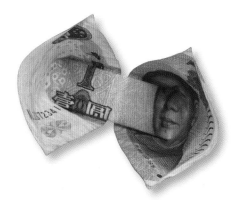

HINT: Bending the bottom points of the bowls upward, facing out, can help the model stand.

Memorabilia Holder

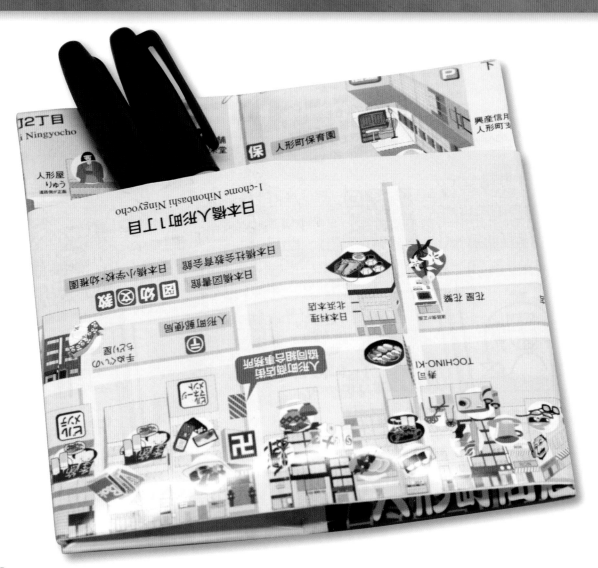

Just the thing for holding ticket stubs, admission tags, nametags, and all the other mementos you hate to throw out. Make one of these little pockets for every trip or event, and pin them on your bulletin board to remind you of all the places you've been and things you've done. Or, use them to store stamps, pens and other things that have a way of running loose.

Here's how to make these easy organizers.

Start with a rectangular sheet.

1 Fold up.

2 Flip over from side to side.

3 Fold in.

4 Fold in.

5 Flip over from side to side.

6 Fold behind.

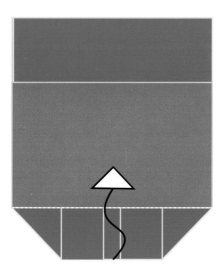

7 Fold bottom up and tuck in. Final result.

Mini Picture Frame

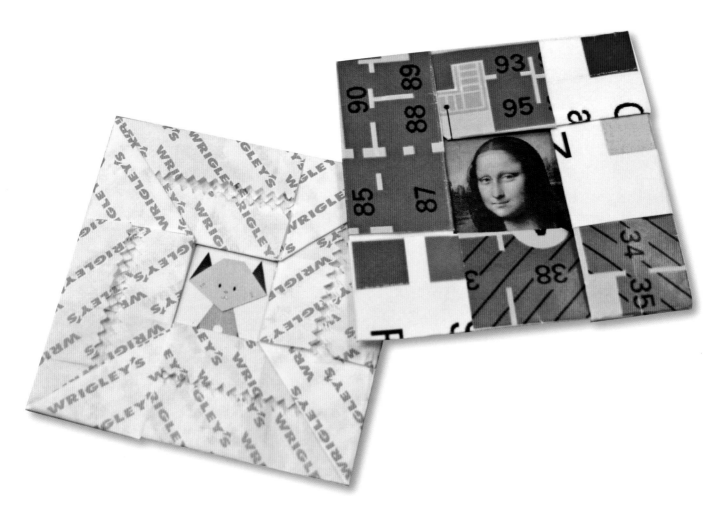

Four stick gum wrappers make this little frame (or you can cut four sheets out of maps, floor plans, pretty patterned paper, paper place mats—whatever you find pretty or nostalgia-provoking). This is a great way to highlight little details that might otherwise go unnoticed, and bring even the smallest memento front and center.

Here's how to make the perfect little frame:

Of course, this basic model works for larger things, too, but it's fun to work within the limited size of, say, a gum wrapper, and use four different paper designs to make a cool, original frame.

1 Fold in to the center.

2 Fold and unfold at the middle, then fold up as shown.

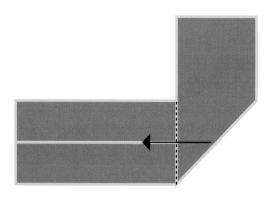

3 Fold to the left.

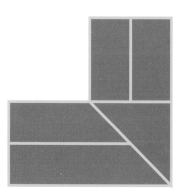

4 Make three more.

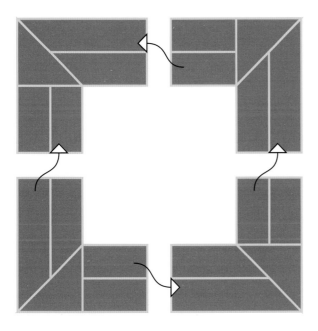

5 Following the diagram, insert the open ends into each other.

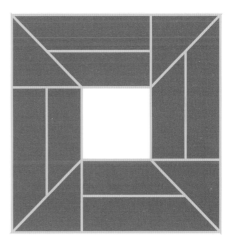

6 This is your finished frame. Frame a picture or a letter and put it on your wall or in your scrapbook.

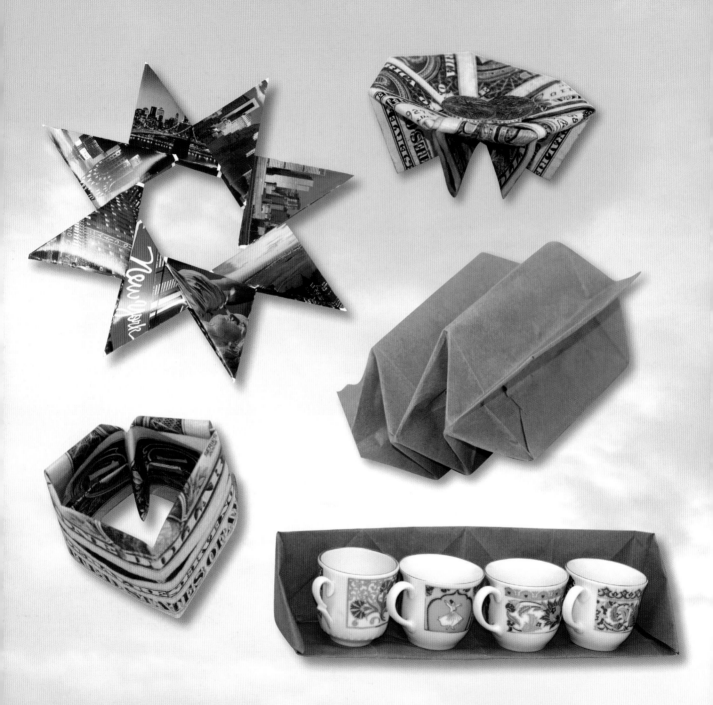

Home Décor Items

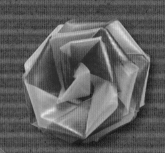

Dollar Heart

I love hearts in any form. This one is super-easy to make, and it's a fun, "heartfelt" way to give money as a gift, or leave as a tip.

How to make your own precious heart.

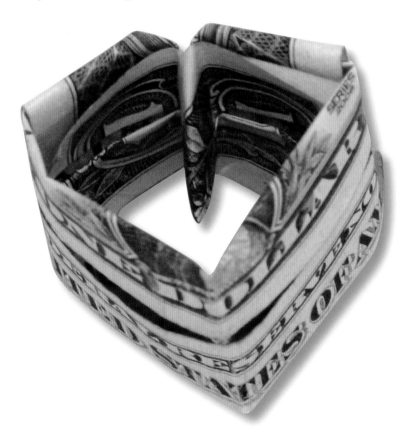

1 Fold in as shown.

2 Flip over from side to side.

3 Fold in.

4 Flip over from side to side.

5 Fold on.

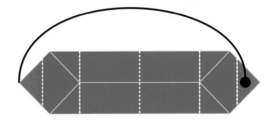

6 Create a heart shape by folding along the dashed lines and inserting the left tip into the right tip.

Money Tray

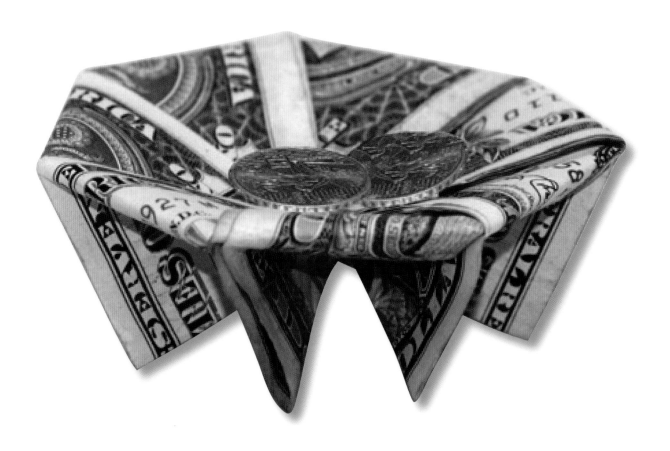

This model lets you use currency to hold your pocket change—or a key or any other little thing that tends to go astray. (This model uses eight bills, so if you're making it for keeps, use singles).

It's also just a pretty home decor item. Make three models for three different countries you've visited. The models will be in different sizes and colors because each country's currency is different.

How to use currency to hold your change.

This footed tray requires adhering pieces together, so if you'd rather not tape up your dollar bills, cut eight sheets the size and shape of a dollar bill.

1 Fold in half as shown.

2 Fold left to right.

3 Fold top right corner to bottom left corner.

4 Flip over from side to side.

5 Fold vertically left to right.

6 Your model will look like this. Make 7 more.

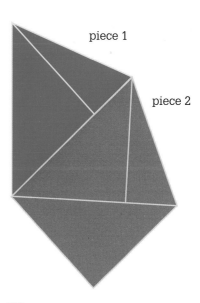

piece 1

piece 2

7 Nestle piece 1 into piece 2, piece 2 into piece 3 and so on, adhering the pieces with double-sided tape as you go along. Your pieces will form a footed circle.

Postcard Star

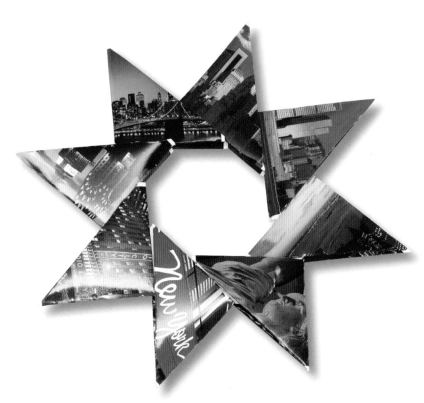

We all find ourselves buying more postcards than we can send, and why not? They're great little souvenirs for keeping as well as for sending. This star is a great way to enjoy lots of memories in one place. Base it on a lot of trips, a single strip, a stop along the way, or even a theme. It only takes eight!!

Create your own starry starry sky.

1 Turn your first postcard so that it's wrong side up. The side you want to show should be face down.

2 Fold the top corners downward as shown.

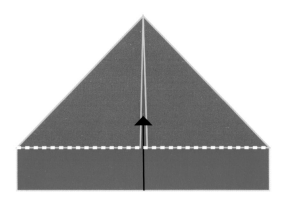

3 Fold the bottom up.

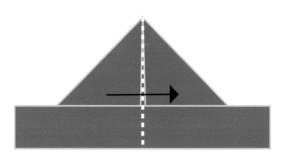

4 Fold in half left to right. Your folded piece will look like this.

5 Make your second model through step 3 and turn your model 90 degrees as shown. Position your first model as shown, then complete step 4 on your second model. folding it over the connecting corner flap on your first model.

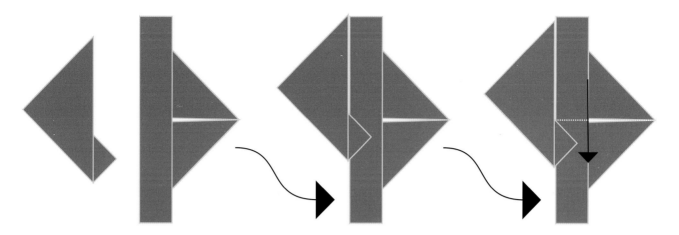

6 Slip a little double-sided tape onto the connecting flap on your first model to stick your pieces together.

7 Do it 6 more times, aligning each corner flap and being careful with your tape each time. This is what it would look like if you had x-ray vision.

8 This is what it'll look like with plain old regular vision.

Paper Shelf

Sometimes it's convenient to have your own sectional for a neat and organized room. I made this one with a paper bag (nice and sturdy), but you can use any paper that's large enough and thick enough to hold what you want to store. You can even use a map to make a spot for…your maps. It's an easy and inexpensive way to personalize any space.

To make your own shelf, start with a sheet that's long enough to hold the things you want.

1 Remove the bottom of the bag.

2 Cut the bag open using a single vertical cut.

3 Lay the bag out horizontally. Fold the bag in half and unfold.

4 Fold in to the center as shown.

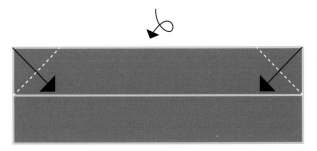

5 Fold Down. Turn from side to side.

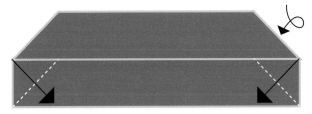

6 Fold sides in. Unfold and turn from side to side.

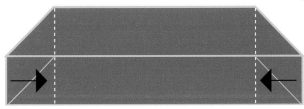

7 Fold sides in. Unfold.

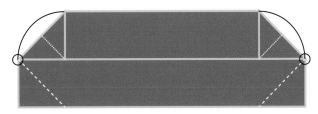

8 Valley fold the top corners and tuck the top by creating a mountain fold over. At the sides, fold the bottom layer inside the top layer.

Diamond Bag

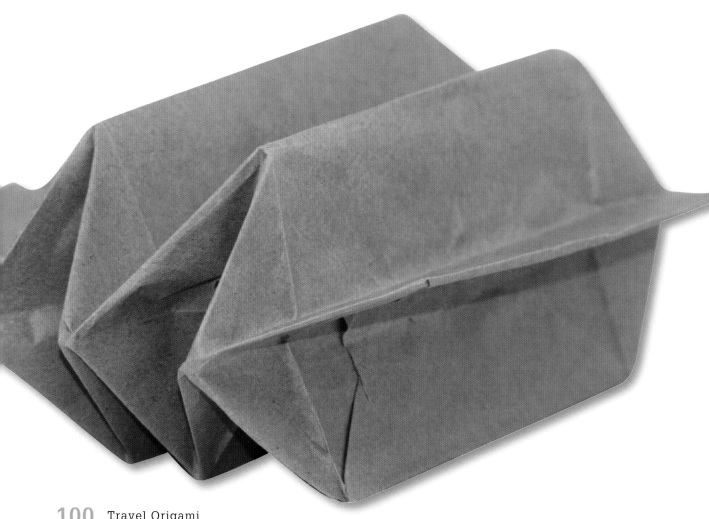

One of my favorite things to do in any metropolitan city is to look at diamonds, not the bling-bling jewelry diamonds, but diamond inspired buildings. To see what I mean check out these sites:

http://unbiasedwriter.com/art/diamond-building-for-east-harlem-by-karim-rashid/

http://www.flickr.com/photos/seanmalloyproductions/7818473566/

http://www.mymodernmet.com/profiles/blogs/the-yas-hotel-in-abu-dhabi-f1

So if you've finished your lunch and have some time to play, convert your lunch bag into this "diamond" model, and puff it in and out like a bellows or accordion and feel the cool breeze come out of the opening. Or dangle it from the top or bottom end for a decorative pendant—makes a great conversation piece!

Here's how to make a diamond bag.

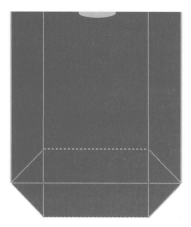

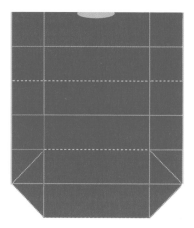

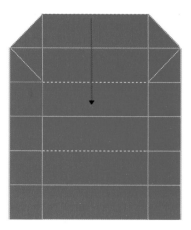

1 Flatten your back with the sides out and the bottom of the bag facing up (the bottom will be a hexagon, and the top half it will flap.

2 Using that flap as a size guide, mountain and valley fold to make accordion pleats. Release. Turn over top to bottom.

3 Fold the bottom of the bag over.

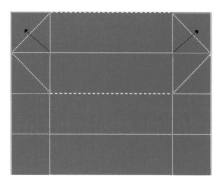

4 Fold down the corners as shown. Do this for each pleat. Your bag will be creased like this.

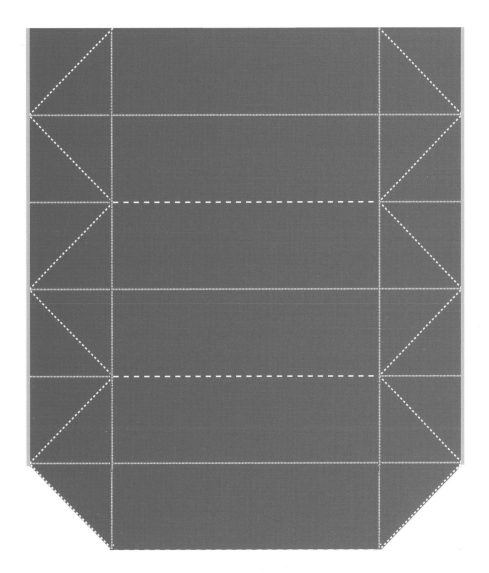

5 Open your bag. Starting at the bottom, tug out the sides of the bag and collapse your pleats one-by-one.

You can also use these views to guide your folds.

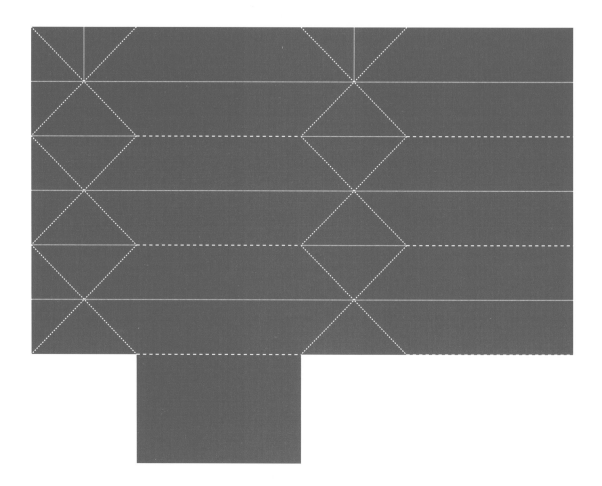

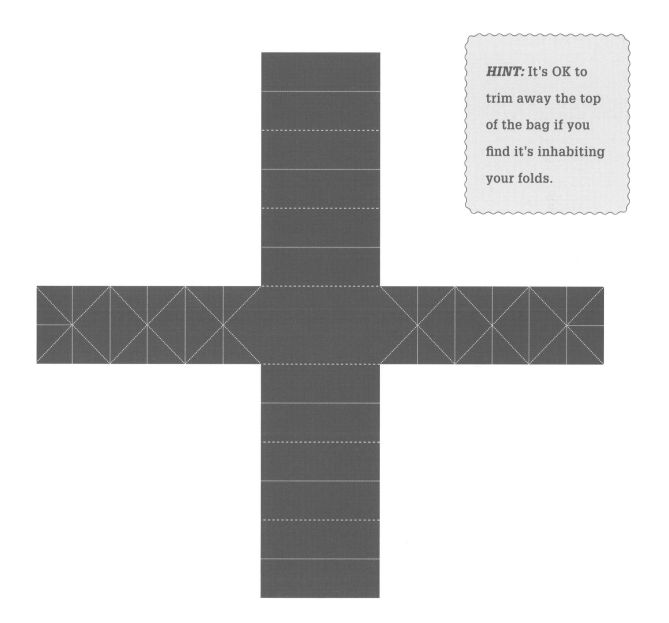

Straw Rose

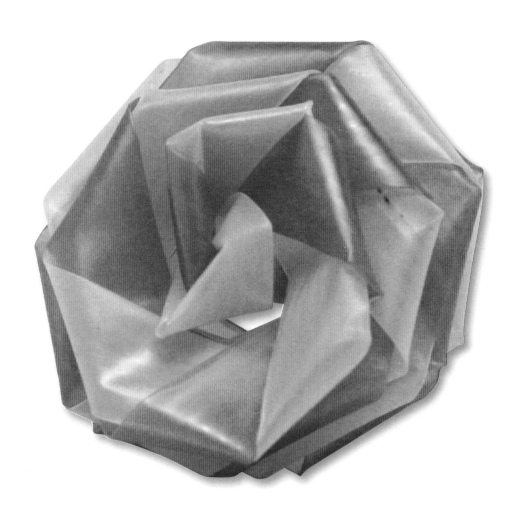

Sometimes, half the fun of traveling is what happens between destinations, especially when the company is just right. Have you ever made a meal stop with family or friends that turned out to be so much fun that you wanted to remember it forever? Making a rose from a couple of the eatery's straws is a great way to do that—a fun flower that brings back memories and lasts forever. (You can do this with any two stiff strips of paper, so use your imagination and make a bouquet!)

Here's how to make a souvenir rose. You'll need two straws (or strips of paper, or ribbons).

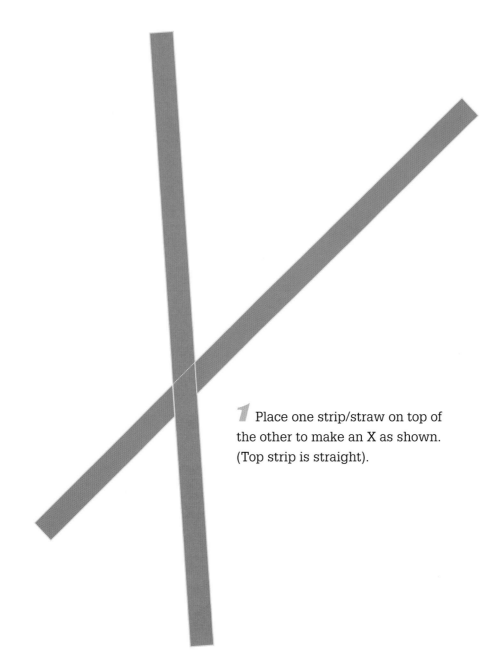

1 Place one strip/straw on top of the other to make an X as shown. (Top strip is straight).

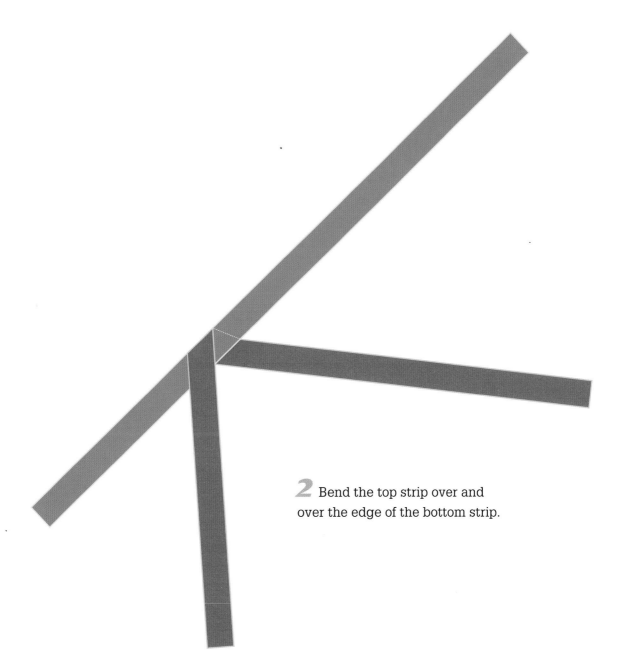

2 Bend the top strip over and over the edge of the bottom strip.

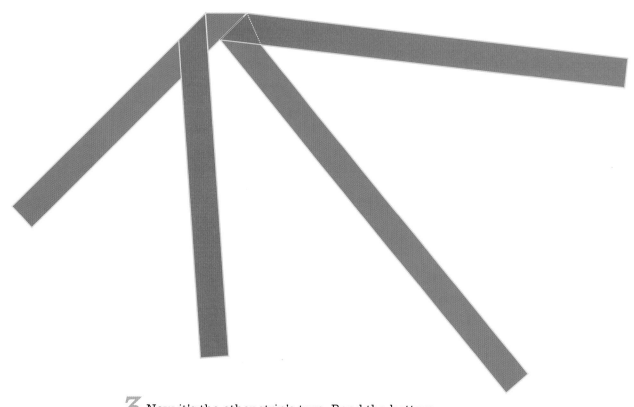

3 Now it's the other strip's turn. Bend the bottom strip over and along the edge of the top strip.

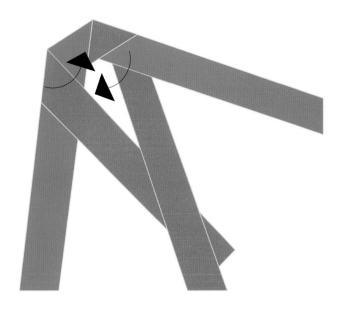

4 Repeat steps 1 and 2, alternating between the two strips. The base of the flower will start to appear circular.

5 As you approach a full circle, rotate the beginning of the bend created in step 1 counterclockwise to form a stem. Keep bending the straws over each other, forming a spiral. Tuck in the last bit of your strip.

If you're using fabric you may want to secure your flower with a few stitches. If you're using straws you may want to tie a knot

Shopping Bag Lamp

Here's another great way to use that shopping bag you'd rather keep than recycle. Upcycle it into a lamp! It's really easy to do, and with the right bag the results can look fabulous. A reasonably translucent bag works best. (Always be careful when exposing paper to heat. Don't let the bag get too close to a hot light source. Battery-operated tea lights or fairy lights are a good bet, and can look really magical.)

Light shining through the diamond patterns on this lamp can give dimension and texture to any room.

Here's how to brighten your room or your evening.

1 Cut off any handles.

2 Remove bag bottom. Your bag will look like this.

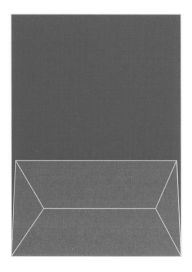

3 The bag will have 2 large and 2 small sides. This is what your bag would look like if you cut it down one side and laid it out. DO NOT CUT YOUR BAG!

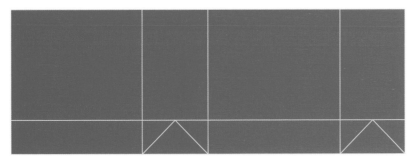

4 Use the existing creases to help you make horizontal and vertical folds, as shown.

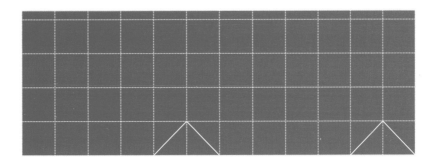

5 Make diagonal folds, using the squares you made in step 3 as a guide.

6 That's it! To be extra safe stand it around a battery powered candle, or drop in a string of fairy batter-powered fairy lights!

Resources

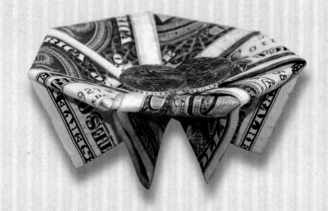

MATERIALS

There's tons of free paper out there,
waiting to be folded into something fantastic.

LOCAL MAPS

Besides the usual road maps, most tourist destinations
offer free maps of the area. These are nice and colorful,
highlighting the shops, restaurants, local museums, and other
fun places to visit. You can find these in more places than you
might think—ski areas, leaf-peeping destinations, towns that
have seasonal festivals are just a few of the types of places
that have these maps on offer in local restaurants and hotels.

GREAT SHOPPING BAGS

Ever find yourself hanging onto a shopping bag because the
color, texture or logo was so nice? If you can't reuse the bag,
fold it! Many bags are made of really durable materials that
can stand up to becoming a wallet for your credit cards or
a holder for your paper odds and ends, like ticket stubs and
other little mementoes.

WRAPPING PAPER

Ever notice how many fantastic wrapping papers there are out there? And it's not just for giftwrapping! When you travel outside of the country, you'll notice that lots of shops wrap your purchases up in parcels (you supply the shopping bag), and some internet vendors will wrap up your purchase as a nice little touch before boxing and shipping your order.

RESTAURANT PLACE MATS

The same restaurant where you find straws to fold into flowers probably uses paper placemats. Fold one up as a nice souvenir of a night out with friends—maybe even get your friends to scribble their names on it before you fold.

OLD BOOKS AND DUST JACKETS

Print is popular! The craft of book alteration has taken away a lot of the guilt we used to feel about tearing up old books. If you like the font and texture (and text) of a book that's well past its prime, try folding something from the pages and dust jacket.

OTHER SOURCES OF FUN FREE PAPER

Museum floor guides, store maps (some stores are big enough to need them) leaflets for special attractions (you can find huge numbers of these in hotel lobbies and rest stops), free city magazines and newspapers, free promotional postcards—these are just a few sources of free paper.

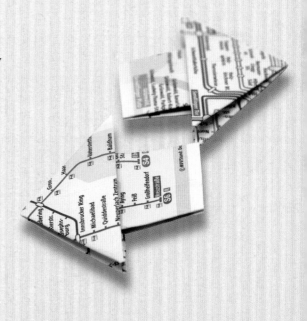

Acknowledgments

Many thanks to:

- agent Regina Brooks who did the most important leg work at the beginning of this process.
- sales and marketing director Christopher Johns who brainstormed ideas with me before the book came to be.
- editor Terri Jadick who patiently and graciously waited for me to submit revisions and content.
- all my friends who contributed their travel remnants to the book: Skye Akiyama, JooYoung Oh, Ginger Dhaliwal, and Susan Thomas.

About the Author

Cindy Ng, author of Girligami – a fresh, fun, fashionable spin on origami was born in Hong Kong and grew up in the San Francisco Bay Area. Upon her graduation from UC Davis with a Bachelor's of Science in Business Economics, she designed a line of origami kits and jewelry which is now sold to the most prestigious museums worldwide, including SF MOMA , The Art Institute of Chicago, The Smithsonian, and The Victoria and Albert Museum. Her work has been featured in Real Simple, Daily Candy, The Washington Post, New York Times and ABC's "The View from the Bay". Cindy now lives in New York and in her spare time she swims and practices karate. Visit her at scrappycindy.com.

Published by Tuttle Publishing, an imprint of Periplus Editions (HK) Ltd.

www.tuttlepublishing.com

Library of Congress Cataloging-in-Publication Data in process

ISBN 978-4-8053-1206-3

Distributed by

North America, Latin America & Europe
Tuttle Publishing
364 Innovation Drive, North Clarendon, VT 05759-9436 U.S.A.
Tel: 1 (802) 773-8930 | Fax: 1 (802) 773-6993
info@tuttlepublishing.com | www.tuttlepublishing.com

Japan
Tuttle Publishing
Yaekari Building, 3F, 5-4-12 Osaki, Shinagawa-ku, Tokyo 141-0032
Tel: (81) 3 5437-0171 | Fax: (81) 3 5437-0755
sales@tuttle.co.jp | www.tuttle.co.jp

Asia Pacific
Berkeley Books Pte Ltd
61 Tai Seng Avenue #02-12, Singapore 534167
Tel: (65) 6280-1330 | Fax: (65) 6280-6290
inquiries@periplus.com.sg | www.periplus.com

First edition
18 17 16 15 14 5 4 3 2 1 1405EP

Printed in Hong Kong

THE TUTTLE STORY
"Books to Span the East and West"

Most people are surprised to learn that the world's largest publisher of books on Asia had its humble beginnings in the tiny American state of Vermont. The company's founder, Charles Tuttle, came from a New England family steeped in publishing, and his first love was books—especially old and rare editions.

Tuttle's father was a noted antiquarian dealer in Rutland, Vermont. Young Charles honed his knowledge of the trade working in the family bookstore, and later in the rare books section of Columbia University Library. His passion for beautiful books—old and new—never wavered throughout his long career as a bookseller and publisher.

After graduating from Harvard, Tuttle enlisted in the military and in 1945 was sent to Tokyo to work on General Douglas MacArthur's staff. He was tasked with helping to revive the Japanese publishing industry, which had been utterly devastated by the war. When his tour of duty was completed, he left the military, married a talented and beautiful singer, Reiko Chiba, and in 1948 began several successful business ventures.

To his astonishment, Tuttle discovered that postwar Tokyo was actually a book-lover's paradise. He befriended dealers in the Kanda district and began supplying rare Japanese editions to American libraries. He also imported American books to sell to the thousands of GIs stationed in Japan. By 1949, Tuttle's business was thriving, and he opened Tokyo's very first English-language bookstore in the Takashimaya Department Store in Ginza, to great success. Two years later, he began publishing books to fulfill the growing interest of foreigners in all things Asian.

Though a westerner, Tuttle was hugely instrumental in bringing a knowledge of Japan and Asia to a world hungry for information about the East. By the time of his death in 1993, he had published over 6,000 books on Asian culture, history and art—a legacy honored by Emperor Hirohito in 1983 with the "Order of the Sacred Treasure," the highest honor Japan can bestow upon a non-Japanese.

The Tuttle company today maintains an active backlist of some 1,500 titles, many of which have been continuously in print since the 1950s and 1960s—a great testament to Charles Tuttle's skill as a publisher. More than 60 years after its founding, Tuttle Publishing is more active today than at any time in its history, still inspired by Charles Tuttle's core mission—to publish fine books to span the East and West and provide a greater understanding of each.